SALISBURY MUSEUM
ILLUSTRATED

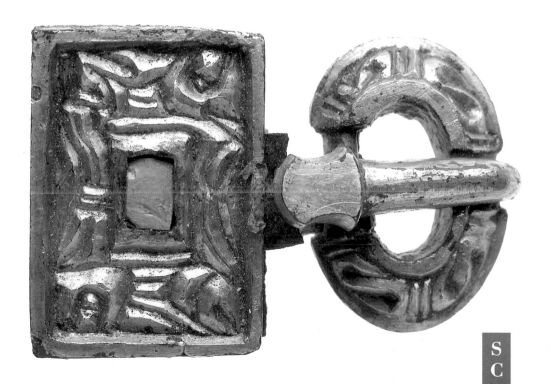

S
C
A
L
A

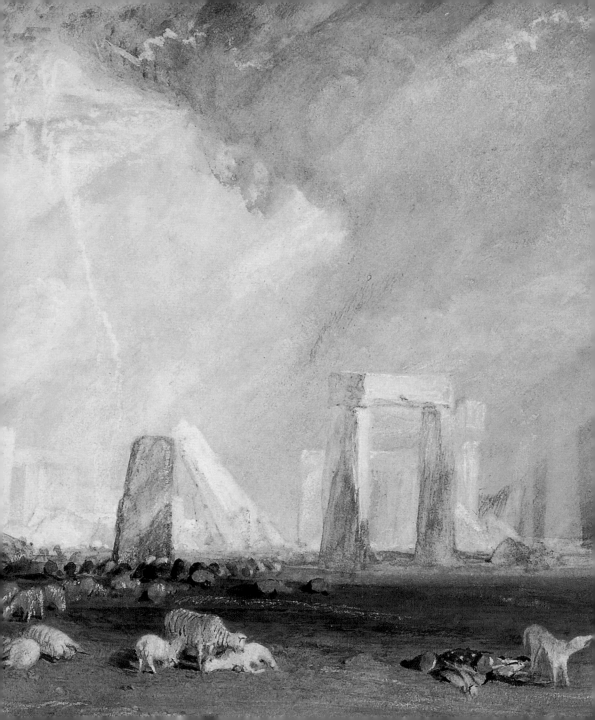

CONTENTS

4 Introduction

7 The King's House

10 Stonehenge

14 Archaeology of Wessex

20 Invaders and Settlers

26 The Pitt-Rivers Collection

30 Old Sarum

32 The Drainage Collection

34 Medieval Salisbury

38 Later Salisbury

44 Paintings, Prints and Drawings

52 Costume and Textiles

56 Ceramics and Glass

60 The Brixie Jarvis Wedgwood Collection

Stonehenge
(detail: see p. 13).

INTRODUCTION

THE SALISBURY MUSEUM IS an award-winning, independent museum based in the King's House, a medieval Grade I listed building located opposite Salisbury Cathedral. The museum has been in existence for over 150 years, and is considered a local treasure.

Our collections span the entire prehistory and history of the Salisbury region – every major period in English history is represented from the Palaeolithic (Old Stone Age) to the modern era.

The museum has one of the best archaeological collections in the country. We have unique finds from the Stonehenge World Heritage Site, the Amesbury Archer (the most important Late Neolithic burial found in the UK) and the Pitt-Rivers Wessex Collection, which offers a remarkable insight into the development of archaeology as a discipline.

Our archaeology collections are so significant that they have been awarded Designated status by the Arts Council. We are one of only a few regional museums to have this status, which is given to pre-eminent collections of national importance. Our collections are key to the understanding of Stonehenge, and of the rich archaeological landscape that surrounds the monument. In addition, our fine art collection includes works by J.M.W. Turner, John Constable, Augustus John and Rex Whistler. We also have impressive collections of costume and ceramics.

The museum's purpose is to encourage learning, research, publication and enjoyment of the collections, seeking to do this in a professional, friendly and stimulating way. We collect, preserve and present objects and information of significance relating to the past of Salisbury and south Wiltshire.

The Great Bustard, 19th century
The bird has a long association with Wiltshire and, since 1937, has appeared on the County crest.

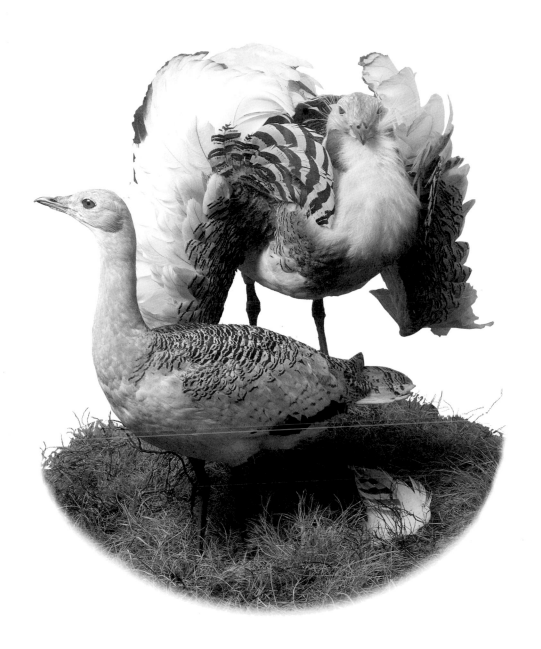

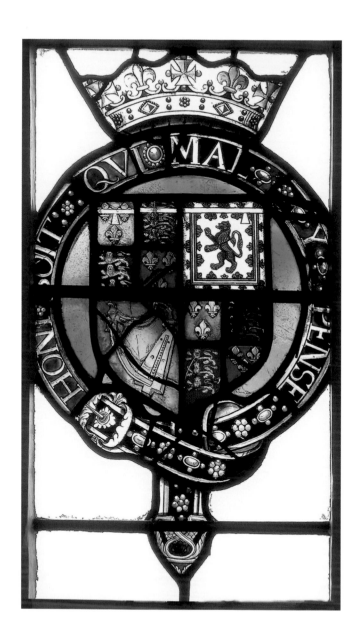

The arms of Henry Prince of Wales (1594–1612), possibly early 17th century
Henry, the eldest son of James I and Anne of Denmark, died of typhoid fever after a short illness. His death meant that his younger brother Charles succeeded James to the throne. These arms are displayed in a window in the former Abbot's Chamber.

The front of the King's House, 1807
JOHN BUCKLER,
Pencil and watercolour.

THE KING'S HOUSE

THE KING'S HOUSE is a building with a history that stretches back to the early 13th century. Before 1539 when Sherborne Abbey was dissolved, this large and important building to the south of the Deanery was the Abbot's prebendal residence in Salisbury. Known then as Sherborne Place, it was originally built in timber but was probably rebuilt in stone in the late 15th century and largely survives at the heart of the museum. The parts most obvious to visitors are the entrance porch, sections of two window jambs in buff-brown Ham Hill stone in the adjacent wall, and the Abbot's chamber with its original fireplace. The museum shop occupies the former

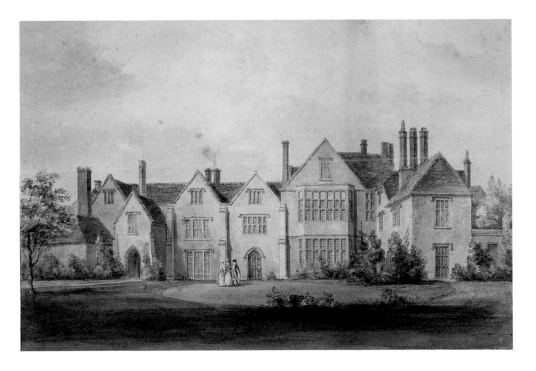

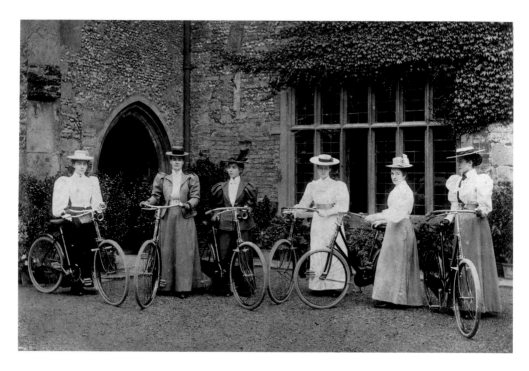

great hall, which would originally have been open to the roof. An exposed panel of wattle and daub infill can be seen be seen in the cross-passage inside the main entrance.

After the Dissolution, the Dean and Chapter were eventually granted the freehold and the house was occupied by a series of secular tenants. At the end of the 16th century, Thomas and Eleanor Sadler erected the brick-built cross-wing to the north of the 15th-century range. This magnificent three-story building with mullioned and transom windows, ornate plaster ceilings and a fine oak-balustered staircase houses the main temporary exhibition gallery on the ground floor, and the ceramics gallery above. It must have been in these fine rooms that James I, with his queen and two young sons, were entertained in 1610 and 1613. It was as a consequence of these visits that the name of the building was changed in about 1780 from Sherborne Place to the King's House.

Photograph of students, 1900
Students of the Diocesan Training College at leisure, posed by the entrance porch.

Thomas Sadler II and his wife Mary hosted the Wiltshire antiquary John Aubrey here in 1656. Throughout most of the 18th century, the house was held by members of the Beach family but sublet as several separate tenements. Among the tenants was Mrs Voysey who ran a school for young ladies for some years until 1799. Lieutenant-General Henry Shrapnel, the inventor of the explosive shell that bears his name, is recorded as living in part of the house in 1785. After a short period of single occupation, with the tenancy of General (later Sir) John Slade, the house was again subdivided in 1837. This time one of the two tenants was Miss Margaret Bazley, the mistress of the Godolphin School. This school subsequently moved into the King's House and remained there until 1848 when an outbreak of cholera in the city caused it to move to a site on Milford Hill, which it still occupies.

From 1851 to 1978 the King's House was home to the Diocesan Training College for Schoolmistresses, latterly the College of Sarum St Michael. Its rules were strict and it was here that Thomas Hardy's sisters studied, doubtless providing the inspiration for Sue Brideshead's escape from the training college at Melchester in *Jude the Obscure*. After the closure of the college the Salisbury Museum bought a 125-year lease on the building and thus from 1981 the King's House has been open to the public as a museum.

Plaster ceiling, c.1600
A detail of the plaster ceiling in the Wedgwood Gallery, formerly the Abbot's Chamber.

STONEHENGE

STONEHENGE IS AN iconic monument of international importance. Together with its immediate landscape and Avebury it is designated a World Heritage Site.

Archaeologists have established fairly clearly by who, how and when Stonehenge was built, but the question of why is still subject to much speculation. That it continued to be a ceremonial centre through periods of major social change is a strong indication of the power exerted by Stonehenge. It is of immense interest that it remained in continual use for so long – some 1,500 years – and this sets it apart from other prehistoric monuments. Its power still exists today, even if it is no longer a political or ritual centre, and it lives as strongly as ever in the popular imagination.

Stone axe, 4000–3000 BC
A highly polished Early Neolithic axe, said to have been 'derived from a barrow near Stonehenge' in the 18th century. According to 19th-century antiquarian Dr Thurnam this was one of the 'most beautiful and elaborately polished stone celts known'. It is made from eclogite, a type of stone which comes from the Italian Alps.

**Mace head,
3000–2400 BC**
Found with a cremation
burial near the southern
entrance of Stonehenge,
this rare Later Neolithic ob-
ject, beautifully made from
gneiss, probably belonged
to a person of high status
and is one of the finest
objects to have been found
at the monument.

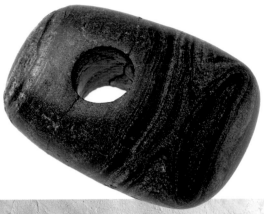

**Male skeleton,
2400–2140 BC**
Murder, accident or sacrifice?
This healthy male, aged 25–
30, was discovered buried
in the ditch of Stonehenge
during excavations in 1978
and found to have died from
multiple arrow wounds.

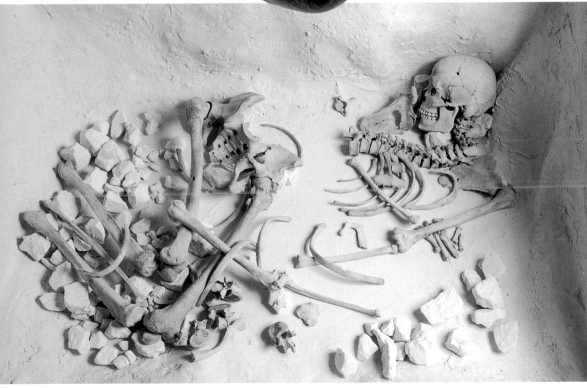

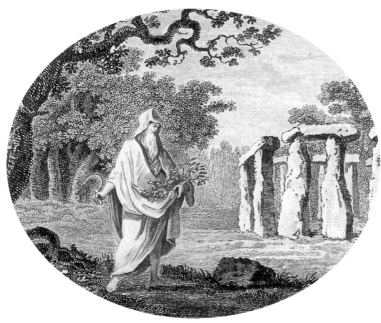

Engraving of druid, late 18th century

Stonehenge has been seen through the eyes of many artists who have been inspired to illustrate the monument. Here an engraver depicts a druid at Stonehenge who has used a scythe to cut down mistletoe in an oak grove. Both oak trees and Stonehenge are associated with druidical ritual, though the monument actually predates the druids and trees never surrounded the stones. From *Antiquities of England and Wales* by Frances Grose.

Inscribed chalk plaques, 3000–2000 BC

From a pit close to Stonehenge, these Late Neolithic or Early Bronze Age plaques are possibly of ritual significance.

**Red deer antler pick,
c.3000 BC**
This antler pick would have
been used for digging the
ditch at Stonehenge.

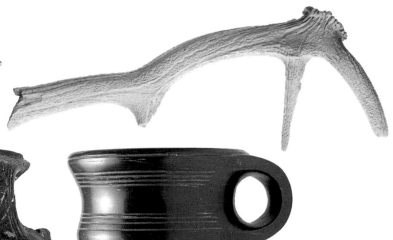

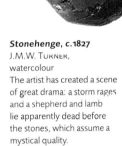

**Shale drinking cup,
c.2000 BC**
An Early Bronze Age cup,
one of two from 'near
Amesbury', shown here with
a modern replica.

Stonehenge, c.1827
J.M.W. TURNER,
watercolour
The artist has created a scene
of great drama: a storm rages
and a shepherd and lamb
lie apparently dead before
the stones, which assume a
mystical quality.

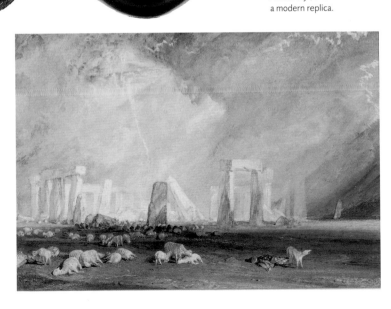

ARCHAEOLOGY OF WESSEX

DESIGNATED AS BEING of outstanding importance, the collections represent the fruits of many decades of excavation, research and collecting in the heart of one of the richest archaeological regions of Britain. From the earliest hunter/gatherer of the Palaeolithic (Old Stone Age) to the Norman period, the archaeology collection spans over 500,000 years and contains an extraordinary range of objects that relate to life and death, ritual and symbolism: from the most basic of flint tools to the most extravagantly decorated and shaped cremation urns, and from the simplest of pins to the most elaborate items of adornment.

The archaeology of the Neolithic (New Stone Age) is represented in the collections by finds from Fussell's Lodge long barrow, Durrington Walls henge monument and Easton Down flint mine, together with a large collection of flint and stone implements from across south Wiltshire that were manufactured and used by the earliest agriculturalists.

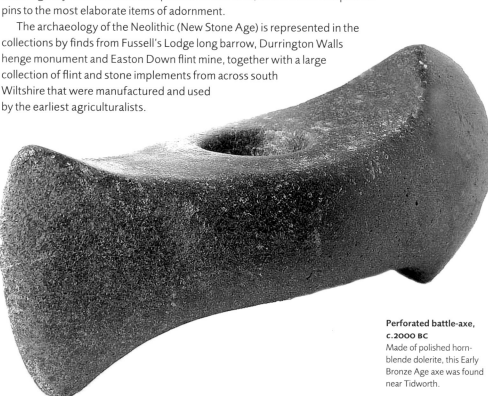

Perforated battle-axe, c.2000 BC
Made of polished horn-blende dolerite, this Early Bronze Age axe was found near Tidworth.

Neolithic 'tool kit'
c.3500 BC
Polished stone axe,
chipped flint axe
and flint sickle from
East Knoyle.

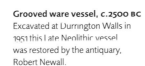

Pottery incense cup, c.2000 BC
Early Bronze Age cup, from a burial
mound at Wylye.

Grooved ware vessel, c.2500 BC
Excavated at Durrington Walls in
1951 this Late Neolithic vessel
was restored by the antiquary,
Robert Newall.

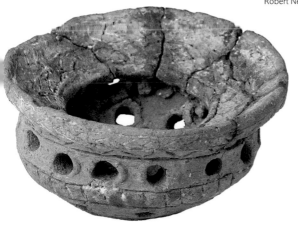

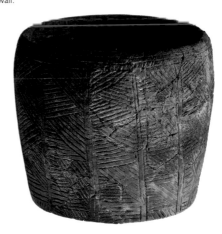

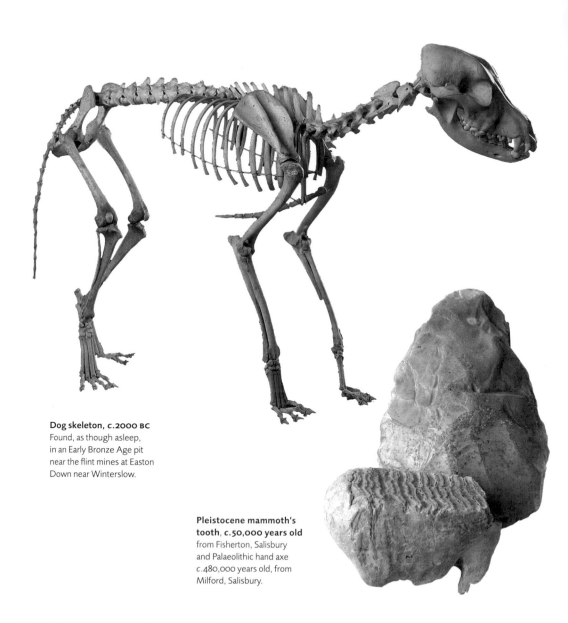

Dog skeleton, c.2000 BC
Found, as though asleep,
in an Early Bronze Age pit
near the flint mines at Easton
Down near Winterslow.

**Pleistocene mammoth's
tooth, c.50,000 years old**
from Fisherton, Salisbury
and Palaeolithic hand axe
c.480,000 years old, from
Milford, Salisbury.

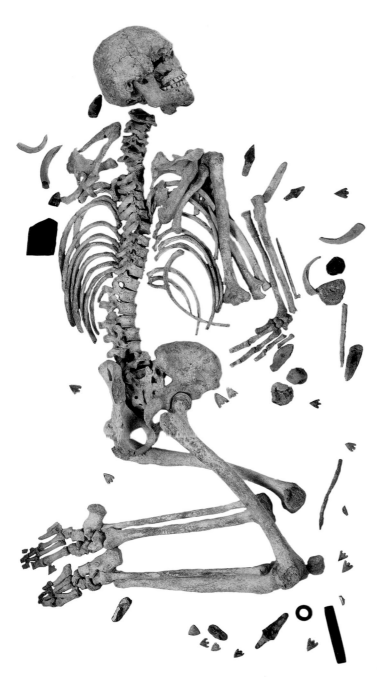

The Amesbury Archer, c.2300 BC

The museum contains one of the foremost Bronze Age collections in the country. Among the more significant finds is the internationally important Late Neolithic discovery known as the 'Amesbury Archer'. This is one of the richest burials of this period known from Britain and contains the earliest dated gold. More significantly, the man interred appears to have originated from somewhere in the Alpine region of continental Europe before coming to this area, finally to be buried just a short distance from Stonehenge.

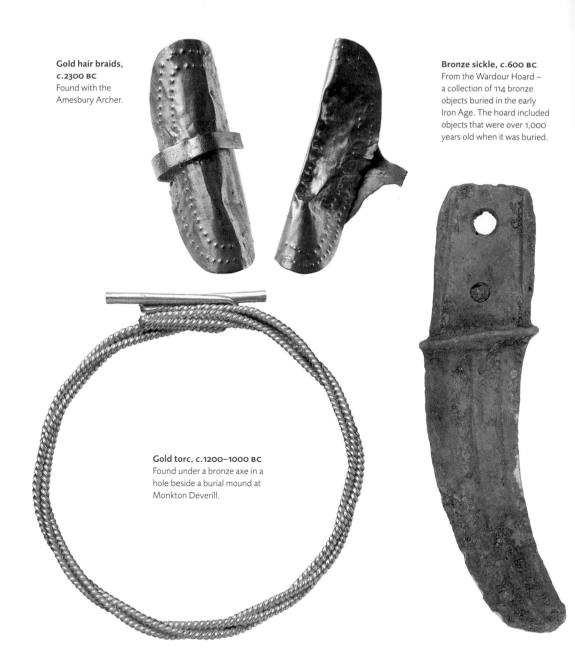

**Gold hair braids,
c.2300 BC**
Found with the
Amesbury Archer.

Bronze sickle, c.600 BC
From the Wardour Hoard –
a collection of 114 bronze
objects buried in the early
Iron Age. The hoard included
objects that were over 1,000
years old when it was buried.

Gold torc, c.1200–1000 BC
Found under a bronze axe in a
hole beside a burial mound at
Monkton Deverill.

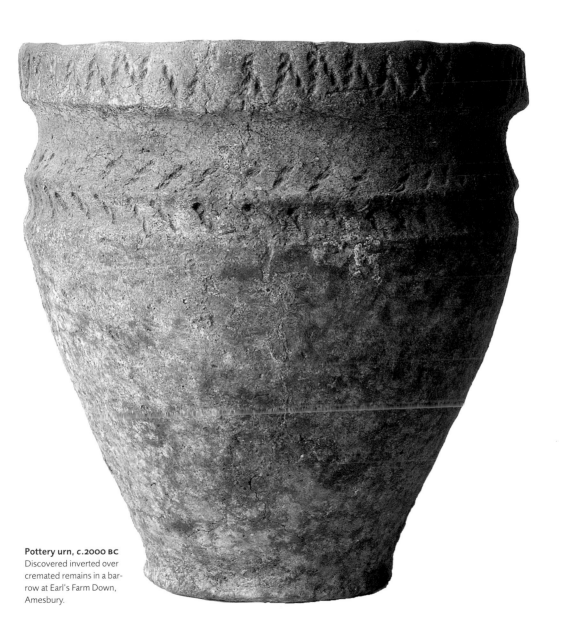

Pottery urn, c.2000 BC
Discovered inverted over cremated remains in a barrow at Earl's Farm Down, Amesbury.

INVADERS AND SETTLERS

THE PERIOD KNOWN as the Iron Age began around 800 BC and is
traditionally deemed to have ended in AD 43 with the Roman invasion
of Britain. In the south Wiltshire area the landscape contained a mixture
of small individual settlements and hill forts. The collections reflect this
with material from Iron Age settlements at Hanging Langford and Stockton
earthworks; from sites along the Grovely Ridge; from Old Sarum, Harnham
Hill and Highfields in Salisbury; and from across Salisbury Plain.

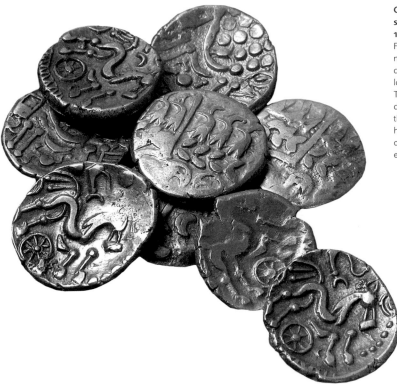

**Collection of 17 gold
staters (coins),
1st century BC**
Found by metal detectorists
near Bowerchalke, these
coins are associated with a
local tribe, the Durotriges.
The designs are derived from
classical Greek prototypes –
the coins display the abstract
head of the Greek god Apollo
on the obverse and a disjoint-
ed horse on the reverse.

The Roman collections reflect the rural nature of south Wiltshire and the continuing occupation of many Iron Age settlements. In addition, however, many objects display the increasing availability of imported goods such as glass and fine ceramics. There are luxury items like the mosaic pavement from the Roman villa at Downton, as well as objects of symbolic or religious significance such as a fine carved stone head from Winterslow.

Iron Age sword, 2nd century BC
Said to be from near Chiselbury Camp, Fovant, the stylised decoration on the scabbard of this rare sword perhaps represents two dragons.

Wheel-thrown pots, 3rd–4th century AD
Distinctive Romano-British pots produced in the New Forest.

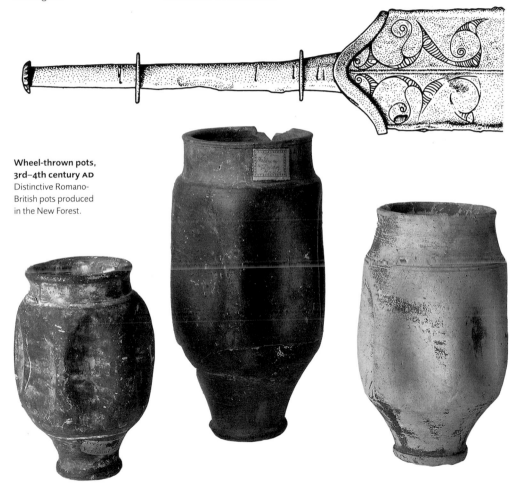

**Gold solidus of Valentinian II
(reigned AD 375 to 392)
and two gold rings,
late 4th century AD**
From a Roman hoard found
near Bowerchalke.

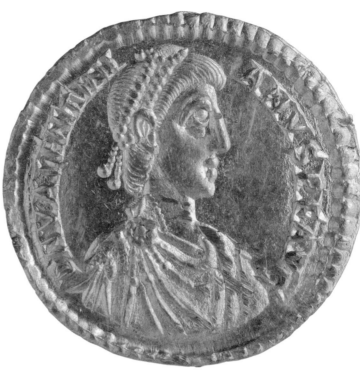

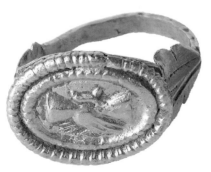

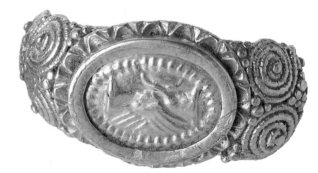

**Copper-alloy
figure of Mercury,
2nd or 3rd century AD**
Romano-British figure from
Salterton near Durnford.
Mercury was the god of
trade and travel. He is shown
here carrying a purse and a
herald's staff and wearing a
winged hat.

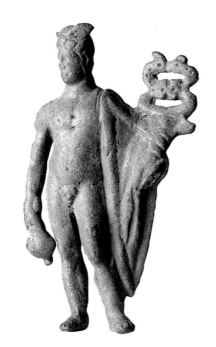

**Samian ware bowl,
2nd century AD**
Made in France in the
Roman period, this bowl
was found at Woodcuts.
Pitt-Rivers Collection.

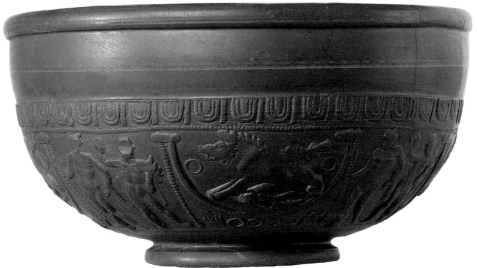

THE MUSEUM HAS a remarkable array of Anglo-Saxon grave goods from cemeteries at Petersfinger, Charlton Plantation, Winterbourne Gunner and others from the 5th and 6th centuries AD. There are also finds from a rich female grave at Swallowcliffe and a warrior burial at Ford.

Gilded bird-shaped brooch, 6th century AD
This was found by a metal detectorist near Milston. This type of Anglo-Saxon brooch is more commonly found on the continent.

Glass cup and gold/silver satchel mount, late 7th century AD
From a rich grave at Swallowcliffe.

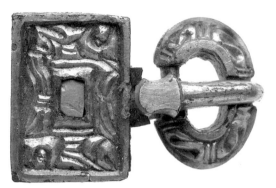

Gilt buckle and small saucer brooch, 5th–6th century AD
These objects were found with burials in the cemetery at Petersfinger. The decoration on the brooch represents a human face.

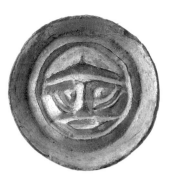

The Warminster Jewel, 9th century AD
This is an aestel (manuscript pointer), found by a metal detectorist in a field near Cley Hill, Warminster in 1997. The jewel is made from rock crystal and set in a beaded wire frame of gold. At the centre there is either a blue glass bead or a lapis lazuli cabochon (a gemstone that has been shaped and polished). The gold shaft would have held an ivory or wood pointer to be used as an aid to reading.

Alfred, King of Wessex (AD 871–899), sent aestels to all the dioceses in his kingdom to accompany his translation of Pope Gregory's Pastoral Care. They are very rare objects. The most famous example is the Alfred Jewel in the Ashmolean Museum, Oxford. The aestel is a symbol of Alfred the Great's desire to encourage spiritual learning throughout his kingdom.

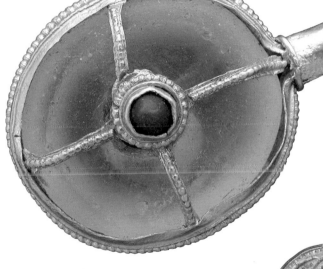

Gold pendants, 7th century AD
From a grave of a Saxon woman buried at Mere. The coloured inlay creates a cross motif possibly indicative of Christianity overtaking the pagan tradition. The tear-shaped pendant is inlaid with garnet.

THE PITT-RIVERS COLLECTION

THIS COLLECTION, made by Lieutenant-General Augustus Henry Lane Fox
Pitt-Rivers (1827–1900), forms a unique chapter in the history of the
development of archaeology and museums. Pitt-Rivers is known to have declared
– 'I inherited the Rivers' estates in 1880 ... Having retired from active service ...
I determined to devote the remaining portion of my life to an examination of the
antiquities on my own property.' This he did, and his discoveries in Cranborne
Chase are displayed alongside scale models of his excavations.

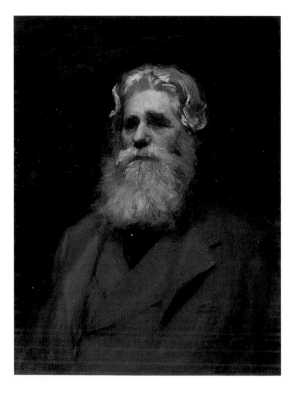

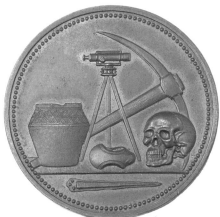

**Lt-General Augustus
Henry Lane Fox
Pitt-Rivers, 1897**
FREDERICK BEAUMOUNT,
oil painting.
This was painted
towards the end of
Pitt-Rivers' life, he was
to die three years later
at the age of 73.

**Bronze medalet,
late 19th century**
The design on this
medal was produced
by fellow archaeologist
Sir John Evans. Copies
were placed by the
General in his excavation
trenches to show future
archaeologists the areas
he had excavated.

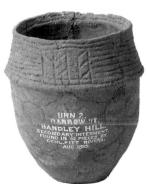

Shale tablet, urn and one of the General's volumes, 1st century AD, c.2000 BC and 19th century
The Roman tablet was used as inspiration for the cover design of this magnificent volume reporting on the General's excavations in Cranborne Chase. The Bronze Age urn is from one of those excavations.

Pitt-Rivers developed a theory of cultural evolution based upon his observations of typology or the classification of objects. This was inspired by the work of Charles Darwin. He was also a pioneer in establishing archaeology as a scientific pursuit. He excavated a wider range of sites more fully and carefully than previous antiquarians. He recorded, analysed and published his discoveries in a more rigorous way and suggested new methods and fields of enquiry. He became the very first Inspector of Ancient Monuments.

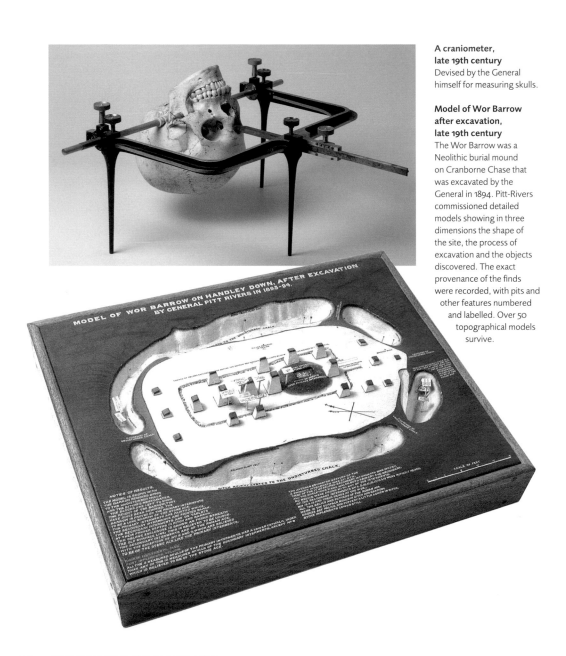

**A craniometer,
late 19th century**
Devised by the General
himself for measuring skulls.

**Model of Wor Barrow
after excavation,
late 19th century**
The Wor Barrow was a
Neolithic burial mound
on Cranborne Chase that
was excavated by the
General in 1894. Pitt-Rivers
commissioned detailed
models showing in three
dimensions the shape of
the site, the process of
excavation and the objects
discovered. The exact
provenance of the finds
were recorded, with pits and
other features numbered
and labelled. Over 50
topographical models
survive.

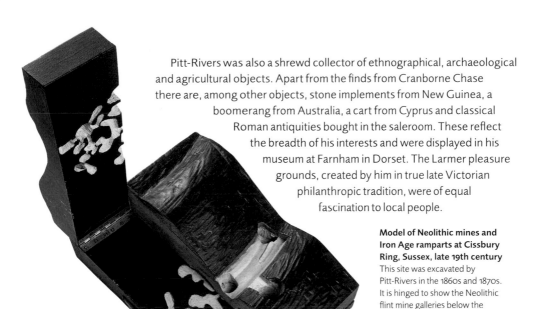

Pitt-Rivers was also a shrewd collector of ethnographical, archaeological and agricultural objects. Apart from the finds from Cranborne Chase there are, among other objects, stone implements from New Guinea, a boomerang from Australia, a cart from Cyprus and classical Roman antiquities bought in the saleroom. These reflect the breadth of his interests and were displayed in his museum at Farnham in Dorset. The Larmer pleasure grounds, created by him in true late Victorian philanthropic tradition, were of equal fascination to local people.

Model of Neolithic mines and Iron Age ramparts at Cissbury Ring, Sussex, late 19th century
This site was excavated by Pitt-Rivers in the 1860s and 1870s. It is hinged to show the Neolithic flint mine galleries below the ramparts of the hill fort. This is one of Pitt-Rivers' earliest models and shows that the flint mines were older than the fort.

Open-air theatre, late 19th century
This theatre at the Larmer pleasure grounds was created by the General in true Victorian philanthropic tradition.

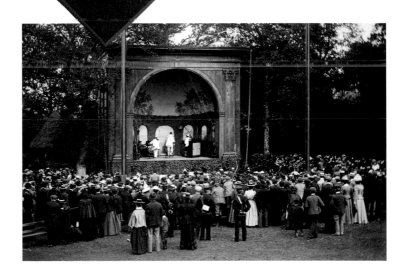

OLD SARUM

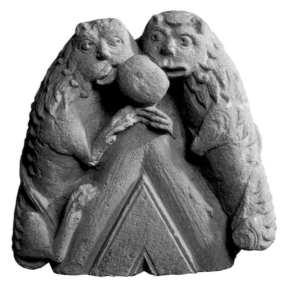

O LD SARUM, originally an Iron Age hill
fort, grew to prominence as a town,
with castle and cathedral, after William the
Conqueror accepted the oath of allegiance
there from the country's landowners
in 1086. In the 1220s the cathedral was
re-established in the valley below and New
Sarum – the site of Salisbury today – quickly
became one of the richest and largest cities
in England.

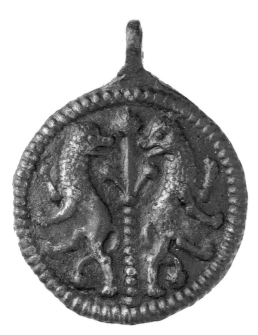

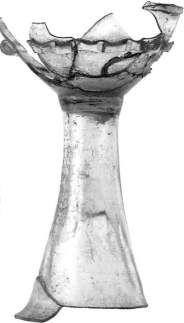

**Stone gablet,
12th century**
Depicting two crouching
lions gnawing at a globe,
this object is from the
cathedral, Old Sarum.

**Copper alloy
harness pendant,
early 13th century**
From the courtyard house,
Old Sarum. Possibly
connected to Ela, Countess
of Salisbury, wife of William
Longespée who is buried in
Salisbury Cathedral.

**Remains of a goblet,
13th to early
14th century**
A rare medieval stemmed
glass goblet, found in a pit
in the castle at Old Sarum.

Commemorative snuff box, 19th century
Made from a piece of the 'Parliament Tree', an elm beneath which Members of Parliament for Old Sarum were elected. Inscribed 'Old Sarum died 7th June 1832, aged 584'.

Romanesque Head of Christ, 12th century
This sculpture was found at the North Canonry, Salisbury, but is likely to have originated at Old Sarum.

Bone chessman, 11th century
From the courtyard house, Old Sarum.

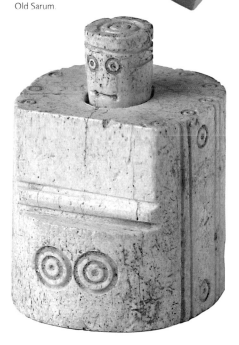

Old Sarum fell into decline, and by the 19th century was one of the notorious rotten boroughs. The excavations of 1909–15 produced some of the most spectacular architectural stonework, pottery and small finds in the museum.

THE DRAINAGE COLLECTION

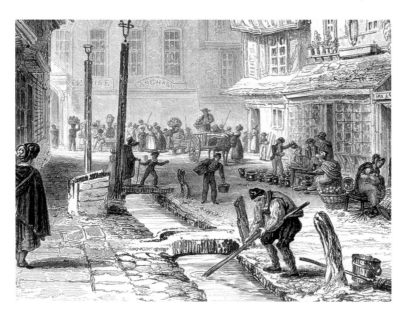

THE FIRST COLLECTION of the museum comprised portable and easily identified objects, which had been recovered in the 1850s as the medieval open drainage channels of the City were replaced by piped water supply and sewers. Keys, knives, spoons, buckles, tokens, tools, seals, badges, spurs, arrowheads and the like provide fascinating reminders of the everyday lives of citizens, merchants, pilgrims, craftsmen and travellers.

Archives reveal that these 'ancient relics' were bought in 1859 for '£32.10.0, cases included'. The museum was thus created; opened, at first, in two rooms in the Market House, it moved in 1864 to St Ann Street where its collections and reputation rapidly grew.

The process of City drainage improvements in what was once called 'the English Venice' thus gave birth to a museum.

Medieval iron arrowhead, 13th–15th century
This broad arrowhead was probably used for hunting large animals such as deer and wild boar. The long barbs ensured the arrow remained in the prey so the animal would slowly bleed to death.

***Minster Street* in 1829**
J. LE KEUX, engraving. Showing a typical open drainage channel.

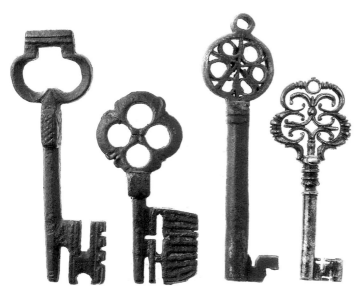

**Medieval keys,
13th–15th century**
A third of all objects from the
Drainage Collection are keys.

**Chess king of walrus ivory,
13th century**
From Ivy Street, Salisbury.

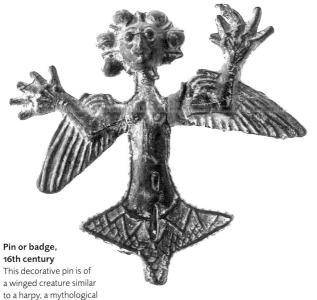

**Pin or badge,
16th century**
This decorative pin is of
a winged creature similar
to a harpy, a mythological
monster.

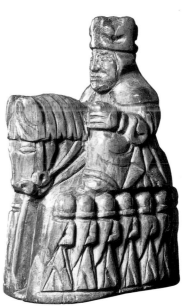

MEDIEVAL SALISBURY

A S WE HAVE SEEN ALREADY, the origin of Salisbury
lay in Old Sarum, and the museum itself in the
'Drainage' Collection.

Apart from the important collections from Old
Sarum and the Drainage Collection, which reflect
military, ecclesiastical and market town life, the
finds from the royal palace at Clarendon, the deserted
village at Gomeldon, the pottery kilns at Laverstock as
well as extensive casual finds throw light on many other
aspects of medieval life.

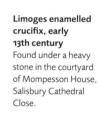

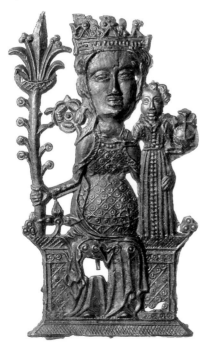

**Pilgrim badge,
early 15th century**
This badge of the Virgin,
Our Lady of Tombelaine,
seated with the infant
Christ, is from northern
France. Found in the river
Avon, Salisbury.

**Window glass,
16th century**
From the site of Ivychurch
Priory near Alderbury, this
late-medieval glass depicts
St James of Compostella.

**Limoges enamelled
crucifix, early
13th century**
Found under a heavy
stone in the courtyard
of Mompesson House,
Salisbury Cathedral
Close.

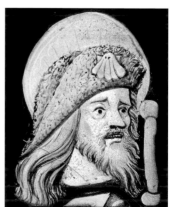

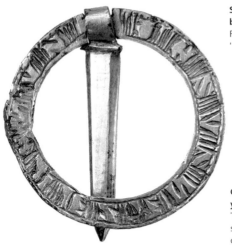

Silver gilt, annular brooch, c.1300
From Amesbury, inscribed 'IESVS NAZARENVN'.

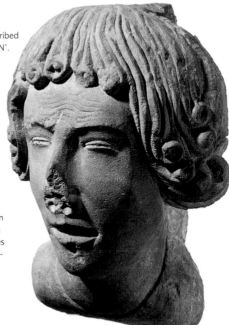

Carved head of a youth, c.1246–56
This most well-known sculpture, which was once coloured, comes from the King's apartments at Clarendon Palace.

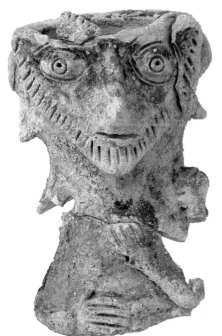

Upper part of a glazed jug, 13th century
Human in form with carefully moulded features, this jug is a fine example of the skill of potters working at Laverstock, near Salisbury.

Jugs, 13th–14th century
From kiln 6 excavated at Laverstock.

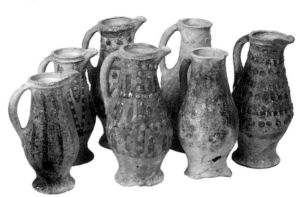

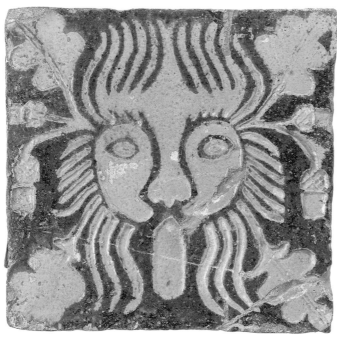

**Inlaid floor tiles,
13th–14th century**
From Great Bedwyn Church, Ivychurch Priory and Clarendon Palace (where there was a tile kiln). Initially, in the 13th century, tiles were used on royal and ecclesiastical sites but later were to be found in buildings of lower status.

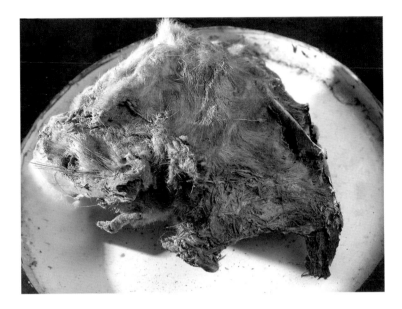

Black rat
Found in the skull of William Longespée (died 1225) when his tomb in Salisbury Cathedral was opened in 1791. A very popular item owing to the suggestion that Longespée probably died through poisoning.

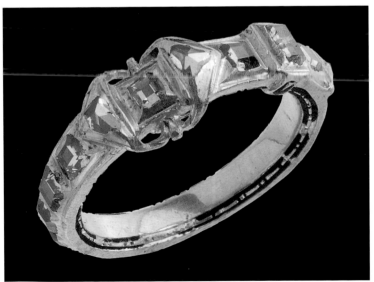

Gold finger ring, mid-16th century
Discovered near Winterbourne Dauntsey. Decorated with 19 diamonds of various cuts set around the hoop. The style of the ring is reminiscent of a belt and the bezel is in the form of a buckle.

LATER SALISBURY

Salisbury's medieval prosperity was based upon the wool trade. Of particular significance are the relics of the ancient guilds of Salisbury, most memorably the Tailors' Giant who towers dramatically above everyone. Civic objects include items salvaged from the Council House fire in 1780, standard weights and measures and collections of Salisbury-made bells, clocks and watches, silver, guns and cutlery. The fame of the latter is commemorated in a rhyme about some of Salisbury's noteworthy features:

> The height of its steeple,
> The pride of its people,
> Its scissors and knives,
> And diligent wives!

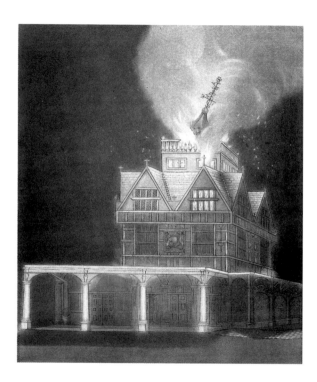

Council House Fire, 1782
Based on illustration by
S. GREEN, etching.
In the early hours of the morning of 16th November 1780, following a banquet given by the newly elected Mayor, Joseph Hinxman, a fire broke out which destroyed the roof and upper floor of the Council House. The *Salisbury* *Journal* recorded that 'a very large and lofty perpendicular blaze of fire...illuminated the whole of the Market Place; and for near an hour afforded a very awful and alarming appearance to the whole city'. A new Council House or Guildhall, as it became known, was completed in 1795, paid for by the Earl of Radnor.

Spire pattern scissors. mid-19th century

Made by Thomas Neesham, who came to Salisbury from Birmingham, setting up his own business in New Canal in 1817.

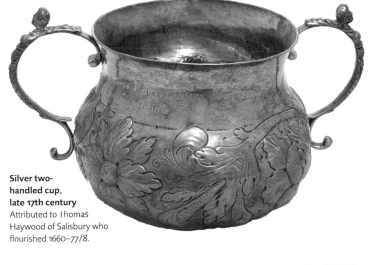

Silver two-handled cup, late 17th century

Attributed to Thomas Haywood of Salisbury who flourished 1660–77/8.

Portrait of William Windover, 1633

Oil on board, restored by Frances Lovibond. Windover was a merchant adventurer and local benefactor who gave financial support to a number of guilds, including the Shoemakers and Bakers. He lived at 24 St Ann Street and was buried in St Martin's Church. The central panel was painted by an unknown artist, the left and right hand panels were painted by Lovibond using a portrait now hanging in the Salisbury Guildhall for reference.

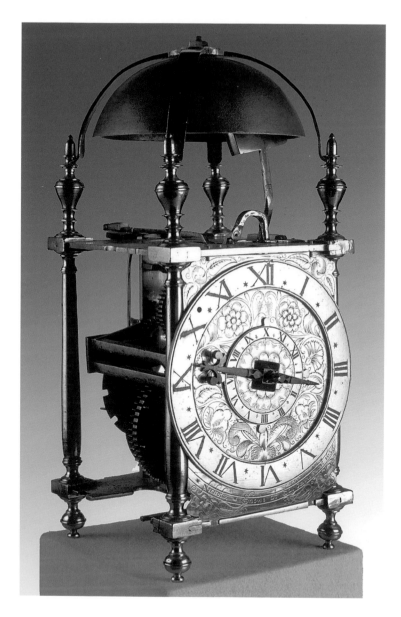

Brass 'lantern' clock, 1636
Signed on the dial 'Nicholas Snowe at Salisburie fecit 1636'. This is one of the very few English clocks made before the Civil War to have survived.

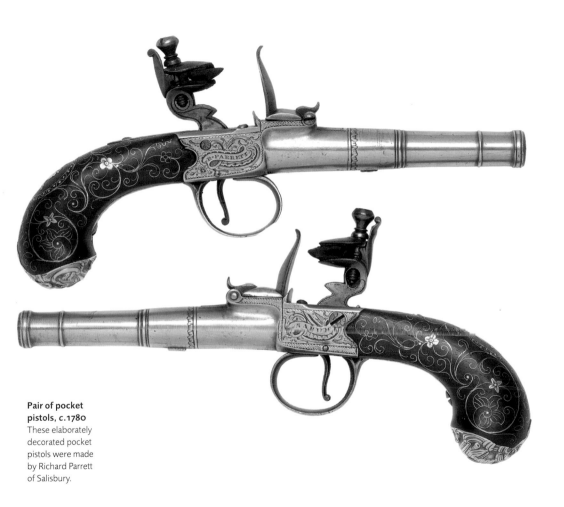

Pair of pocket pistols, c.1780
These elaborately decorated pocket pistols were made by Richard Parrett of Salisbury.

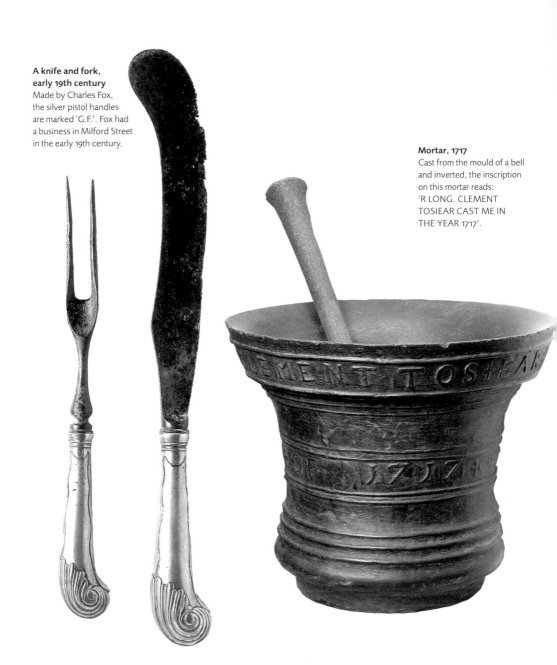

**A knife and fork,
early 19th century**
Made by Charles Fox,
the silver pistol handles
are marked 'G.F.'. Fox had
a business in Milford Street
in the early 19th century.

Mortar, 1717
Cast from the mould of a bell
and inverted, the inscription
on this mortar reads:
'R LONG. CLEMENT
TOSIEAR CAST ME IN
THE YEAR 1717'.

The Giant and Hob-Nob, 15th century

Popularly known as St Christopher he was the pageant figure for the Tailors' guild. The museum purchased him for 30 shillings from the guild in 1870. His companion, the Hob-Nob, was the mischievous character who cavorted in front in the procession clearing the way for the Giant. This is a 19th-century photograph taken outside the old museum building in St Ann Street.

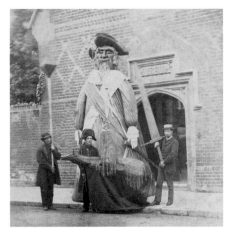

The Scout motor car, 1912

Made by a local manufacturing company in Salisbury, this is one of only two cars that survive today.

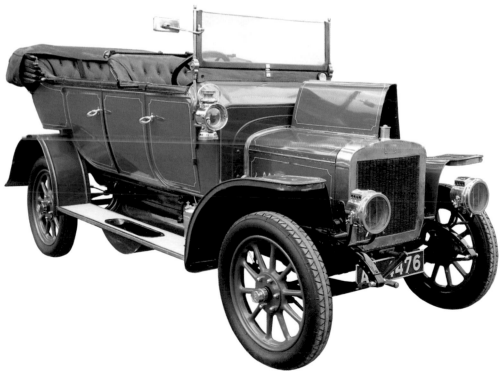

PAINTINGS, PRINTS AND DRAWINGS

THE MUSEUM COLLECTS PAINTINGS, prints and drawings for their historical and artistic interest. The collection is strong in topographical scenes, images of local personalities, particular events and everyday life. It includes five watercolours by J.M.W. Turner, a pencil drawing by John Constable, watercolours by Louise Rayner and the archive of 20th-century artist Rex Whistler.

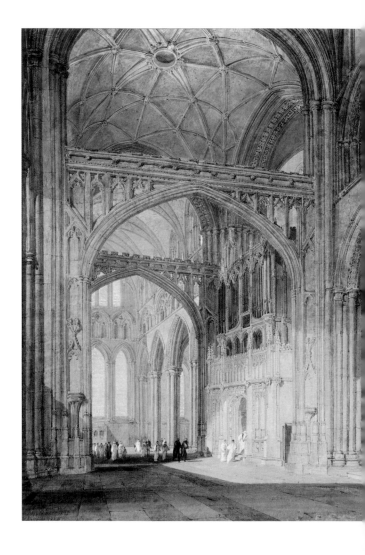

Interior of Salisbury Cathedral looking towards the North Transept, c.1802–5
J.M.W. TURNER, watercolour. One of a series commissioned by Sir Richard Colt Hoare of Stourhead, to illustrate a proposed history of Wiltshire.

Mrs Rideout and the Coombe Express, 1878
FRANK BROOKS, oil painting. Mrs Ridout operated as the prioprietress of a carrier business, conveying goods between the village of Coombe Bissett and 'The Shoulder of Mutton' Inn in Salisbury.

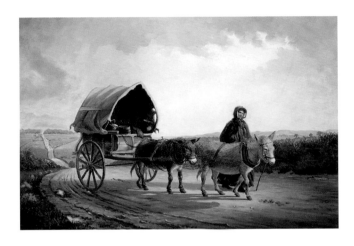

High Street, Salisbury, 1870s
LOUISE RAYNER, watercolour. An interesting pictorial record of Salisbury's busy High Street looking north towards St Thomas's Church.

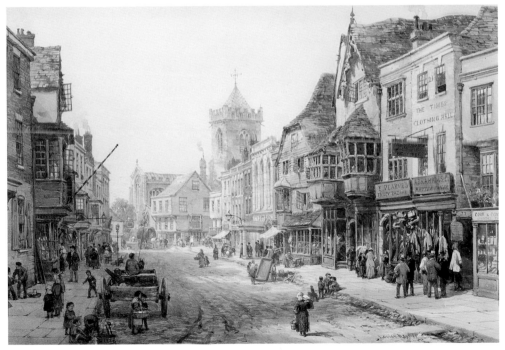

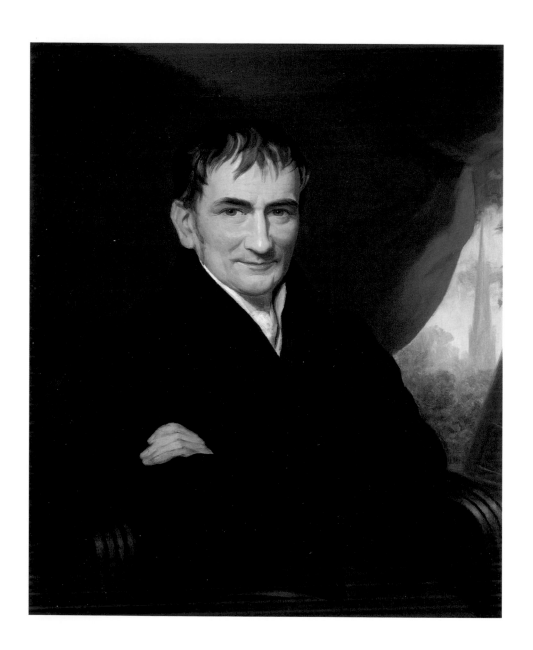

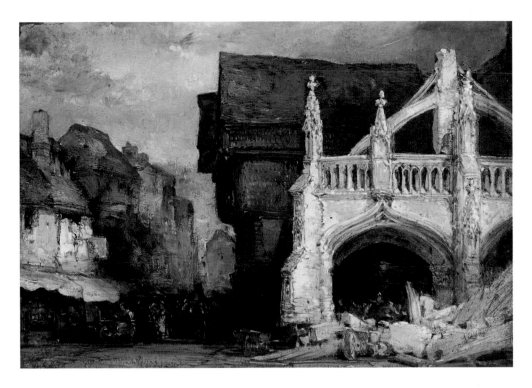

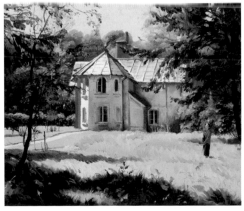

Poultry Cross at Salisbury While Under Repair, c.1874
WILLIAM CALLOW,
oil painting.

Henry Hatcher, 1839
Attributed to T.W. GRAY,
oil painting.
Henry Hatcher was an
antiquary who produced
one of the first authorative
accounts of the history
of Salisbury.

The Daye House, Wilton, 1942
REX WHISTLER, oil painting.
The painting depicts the
artist's good friend and
mentor Edith Olivier and
her home in the parkland
of Wilton House.

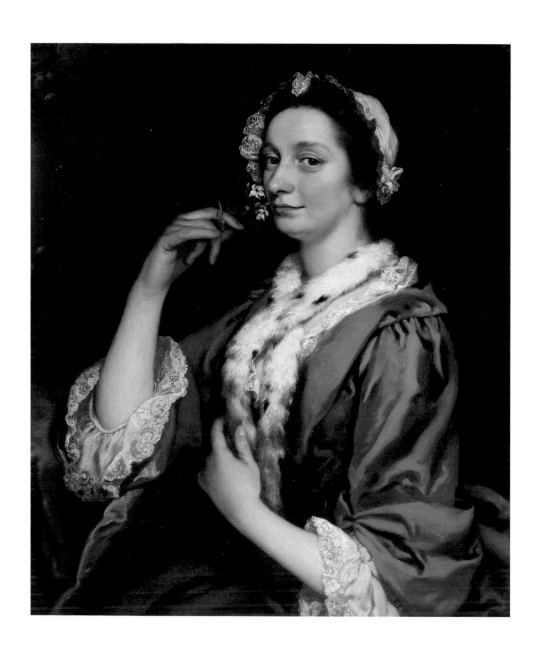

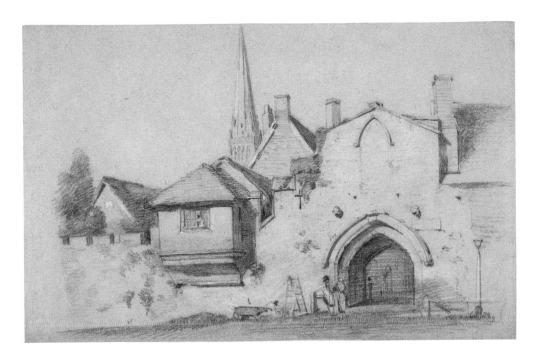

Miss Fort of Alderbury House, 1747
GEORGE BEARE, oil painting.
An assured and elegant
portrait of a local lady in the
English Rocco style.

St Ann's Gate, Close, Salisbury, 1811
JOHN CONSTABLE,
pencil drawing.
Made when the artist accept-
ed an invitation to stay with
the Bishop of Salisbury.

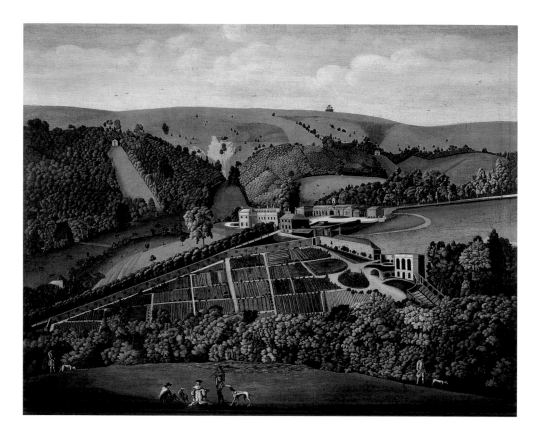

**A panoramic view of
Ashcombe, Wiltshire,
c.1770**
ARTIST UNKNOWN, oil painting.
In the 1930s Ashcombe became
the much loved home of artist
and photographer Cecil Beaton
who wrote after acquiring this
oil painting 'The picture ever
since has been my favourite
possession'.

Grave goods from a barrow near Winterslow, c.1815
THOMAS GUEST, oil painting. These items were found by the Rev. A.B. Hutchins of Grateley in 1814.

COSTUME AND TEXTILES

THE MUSEUM has an important costume and textile collection, which focuses on items made by or associated with local people. The collection is strongest in late 18th- and 19th-century material and numbers an estimated 5,000 items. It represents various aspects of life in south Wiltshire including farming, sporting, military history, church and domestic life.

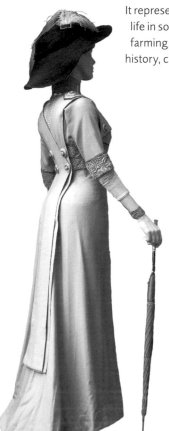

Pale blue woollen dress, c.1911
Lace-trimmed dress with hobble skirt, ostrich-plume straw hat, silk umbrella and hair work bracelet, epitomising Edwardian elegance.

Town crier – a wooden toy, c.1826
With tricorn hat and bell, mounted on a trolley.

Stumpwork mirror, c.1670
From Amesbury, depicting in its frame exquisite portraits of Charles II and his queen, Catherine of Braganza.

French wooden doll, c.1790
This doll is believed to have been dressed by Marie Antoinette – for her daughter – while imprisoned, awaiting execution, during the French Revolution. The dress is trimmed in Binche lace.

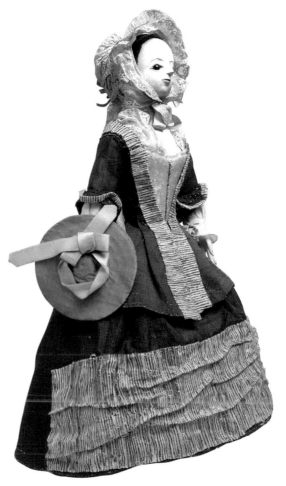

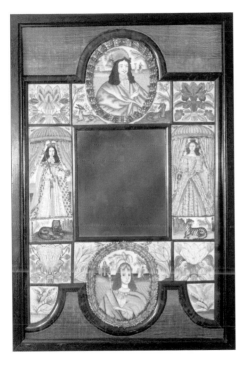

Shoehorn, 1593
The engraving by Robert Mindun of a figure in Elizabethan costume is perhaps of Jane Ayers, the lady named in the inscription. Mindun is the earliest recorded English engraver of horn.

Dr Neighbour's surgery

The museum has the contents of the surgery of Dr Philip Neighbour, who practised in Amesbury from 1939 almost until his death in 1982. It illustrates the equipment, working conditions and outside interests (especially fishing) of a country physician in the era that saw the beginning of the National Health Service.

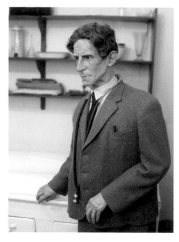

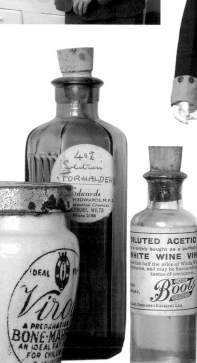

Captain John Swayne, c.1812
A life-sized manikin wearing the uniform of John Swayne, a captain of the 1st Battalion, Wiltshire Local Militia.

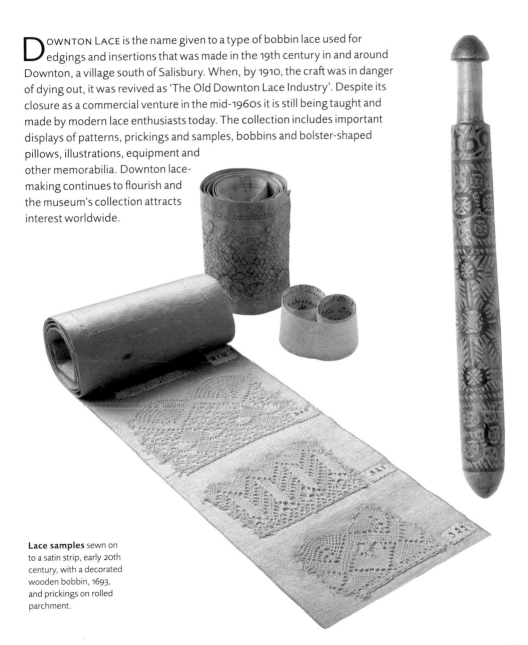

D OWNTON LACE is the name given to a type of bobbin lace used for edgings and insertions that was made in the 19th century in and around Downton, a village south of Salisbury. When, by 1910, the craft was in danger of dying out, it was revived as 'The Old Downton Lace Industry'. Despite its closure as a commercial venture in the mid-1960s it is still being taught and made by modern lace enthusiasts today. The collection includes important displays of patterns, prickings and samples, bobbins and bolster-shaped pillows, illustrations, equipment and other memorabilia. Downton lace-making continues to flourish and the museum's collection attracts interest worldwide.

Lace samples sewn on to a satin strip, early 20th century, with a decorated wooden bobbin, 1693, and prickings on rolled parchment.

CERAMICS AND GLASS

FINE CERAMIC WARE, or china, has been actively collected by the museum since its foundation. In the second half of the 19th century a group of Salisbury ceramic collectors met regularly to share ideas, information and their enthusiasm about the subject. These collectors – people like Walter Tiffin, the Salisbury artist; Dr W.D. Wilkes, a physician at Salisbury infirmary; James Nightingale, the ceramic historian from Wilton – actively advanced the knowledge of the subject.

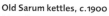

Puzzle jug, 1606
An intriguing example of Wiltshire Brownware, which, despite its name, was actually made in the Alderholt area on the Dorset/Hampshire border.

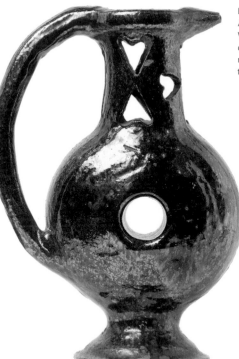

Old Sarum kettles, c.1900
More than 140,000 imitations of the 'kettle' were made and sold locally as souvenirs (see left) at the turn of the 20th century, on the misunderstanding that it had been discovered at Old Sarum. In fact it is a pitcher brought back from North Africa (above).

Three-tiered moneybox, c.1910

One of the more unusual products from the prolific potters of the heathland around Verwood, Dorset. They hawked their great variety of household wares around the Salisbury district for some 500 years until the 1950s.

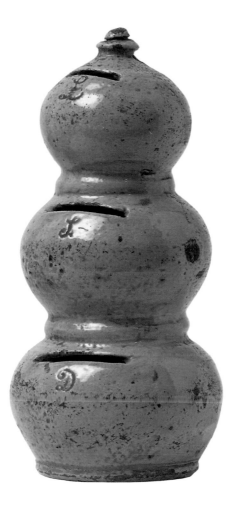

Drinking glass, c.1770–80
This engraved glass with opaque-twist stem is a fine example of 18th-century British glassware.

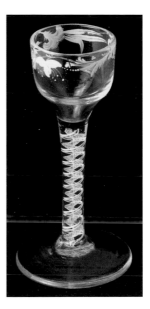

The museum's ceramics collection was formed gradually based on the advice and gifts of these private collectors. Dr Wilkes left his entire collection of pottery and porcelain to the museum after his death in 1899, and the important addition of pieces from Frank Stevens, curator of the museum (1913–49), and many other generous collectors, created a well-defined and carefully researched ceramics collection.

The collection of fine ceramic ware consists primarily of English pottery and porcelain of the 18th and 19th centuries. It is a connoisseur's collection. In addition the museum has collections of more humble crockery manufactured locally in Dorset and Hampshire and items produced for the local tourist market.

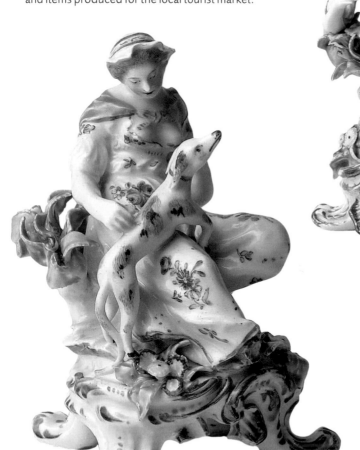

Fine porcelain figures, 1760s
Representing the five senses, *Touch*, *Smell*, *Taste*, *Hearing* and *Sight*, this complete set of figures from the Bow factory in London are a rare and important survival.

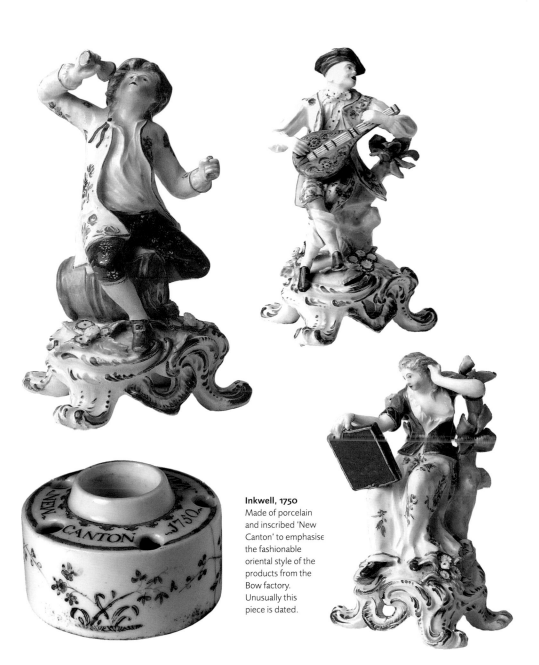

Inkwell, 1750
Made of porcelain
and inscribed 'New
Canton' to emphasise
the fashionable
oriental style of the
products from the
Bow factory.
Unusually this
piece is dated.

THE BRIXIE JARVIS
WEDGWOOD COLLECTION

MRS BRIXIE JARVIS, formerly of Rockbourne, was a
ceramics collector and museum benefactor. Her
Wedgwood collection, of more than 650 pieces amassed
over 40 years, illustrates the outstanding quality, variety and
long history of this famous firm.

The 'Frog' plate, 1774
This plate, decorated with a view
of Mount Edgcumbe in Cornwall,
is one of 952 pieces made by
Josiah Wedgwood for Empress
Catherine II of Russia. Each piece
was decorated with a different
British view and has a green frog
motif. Most surviving pieces of
this famous dinner service are
now in the Hermitage Museum,
St Petersburg.

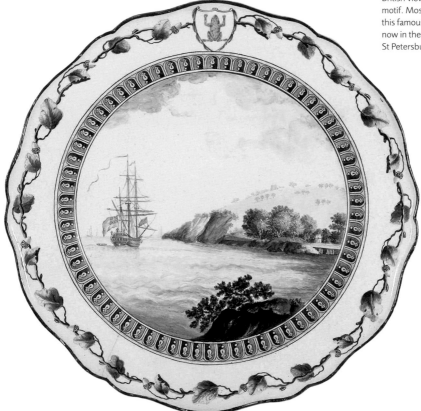

**Saucer-shaped bowl
or tazza, 1858–76**
Wedgwood employed the
French artist Emile Lessore
between 1858 and 1876 to
decorate selected pieces,
such as this one with his own
designs.

Cauliflower teapot, c.1760
Josiah Wedgwood experimented in his early years with new coloured glazes, and one of his first achievements was the vivid green used on this teapot.

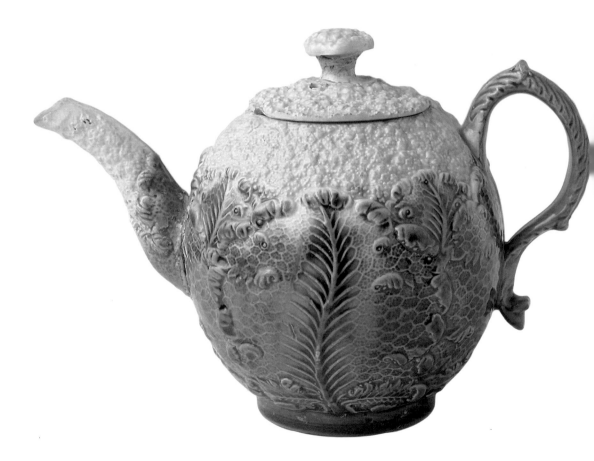

Egyptian-style teapot, c.1850
After Wedgwood's death his company continued to make refined red stoneware (*rosso antico*); this teapot reflects the interest in Egypt which resulted from Nelson's victory at the Battle of the Nile in 1800.

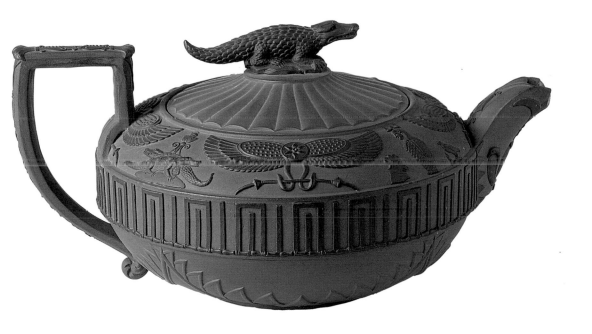

This edition © Scala Arts & Heritage Publishers Ltd, 2014

Text © The Salisbury Museum 2014

First published in 2014 by
Scala Arts & Heritage Publishers Ltd
10 Lion Yard
Tremadoc Road
London SW4 7NQ
Tel: 00 (44)20 7808 1550
www.scalapublishers.com

In association with
The Salisbury Museum
The King's House
65 The Close, Salisbury
Wiltshire SP1 2EN
www.salisburymuseum.org.uk

ISBN 978-1-85759-924-4
Edited by Zoe Charteris
Proofread by Julie Pickard
Designed by Nigel Soper
Printed in Turkey

10 9 8 7 6 5 4 3 2 1

Frontispiece: Gilt buckle
Front cover: Satchel mount
Front cover flap: Amesbury Archer skeleton
Back cover: Pair of pocket pistols
Back cover flap: Gold pendants